Happiness is doin' your thing

First Published in the United States of America in 2009

Gingko Press, Inc.
1321 Fifth Street
Berkeley, CA 94710, USA
Phone (510) 898 1195 / Fax (510) 898 1196
email: books@gingkopress.com
www.gingkopress.com

ISBN: 978-1-58423-347-3

Printed in China

© 2009 JUXTAPOZ
www.juxtapoz.com

Produced by: R. Rock Enterprises
Design by: Justin Van Hoy & Will Hays
Project Manager: Z. Oxford
Writer: Kevin Thomson

All Rights Reserved.
No part of this book may be reproduced or utilized in any form or by any means, mechanical or electronic, including, but not limited to photocopying, scanning and recording by any information and retrieval system, without permission in writing from the publisher.

Previous Page: Image by Pete Millar
Opposite Page: Image by David Perry

Cover: Image by Robert Williams

JUXTAPOZ
CAR CULTURE

CONTENTS

ANTHONY AUSGANG	14
JACK BUTLER	24
C • CRUZ	32
JIMMY C	40
CHURCH	48
COOP	56
DIRTY DONNY	66
MARK D'ESTOUT	74
CHRIS FROGGETT	82
PAT GANAHL	90
BRUCE GOSSETT	98
DARRELL MAYABB	106
M.C. MCMILLEN	114
PETE MILLAR	120
ED NEWTON	128
DAVID PERRY	136
THE PIZZ	146
SARA RAY	154
CHARLIE SMITH	162
THOM TAYLOR	172
PETER VINCENT	180
KEITH WEESNER	190
ROBERT WILLIAMS	198

Opposite page: Image by Pat Ganahl
Following spread: Image by Charlie Smith

CAR CULTURE

INTRODUCTION

Juxtapoz Art & Culture Magazine

The fourth book in an ongoing series from the seminal West Coast art and culture magazine, *Juxtapoz Car Culture*, features some of the best artists from the hot rod and Kustom Kulture worlds. It is pure eye candy for existing fans and an aesthetic eye opener for everyone else.

During the hot rod explosion of the 1950s, an art movement sprang up that originated in the craft of building, decorating and adorning a hot rod or custom. A handful of talented artisans elevated the aspects of the craft to art, paving the way for a subculture that would come to include hot rod-inspired art in the form of cartoons, photography and T-shirt graphics.

Two of the most prominent examples of the 1950s and 1960s expansion of hot rod culture were Von Dutch and Ed "Big Daddy" Roth. Von Dutch was a visionary who took pin striping and customization to new levels, and also created the iconic Flying Eyeball logo. Roth was a custom car builder whose vision was so other dimensional that he made people think differently about what a car could be. Roth also created the Rat Fink cartoon character and a style that inspired artists to devote entire careers to it. Both of these men brought about significant changes in perception and, by definition, created art.

In this book, you will find artists working in all styles and in all mediums. There are stripers in the Von Dutch tradition, illustrators in Roth's style, cartoonists, as well as straightforward practicioners of design. Weaving in and around this core are the painters, photographers, sculptors and conceptual artists who use the imagery and artifacts of this culture to ignite questioning, collective memory or sensory recollection.

Car Culture provides the unique opportunity to fill your imaginary tank and zoom into a segment of the real world populated by those totally devoted to car culture. It features core representatives and originators like Robert Williams, founder of *Juxtapoz*, plus contemporary maniacs like Coop and Keith Weesner. Other artists include Jimmy C, Church, Dirty Donny, Mark D'Estout, Chris Froggett, Pat Ganahl, Bruce Gossett, Darrell Mayabb, Pete Millar, David Perry, Sara Ray, Thom Taylor, Peter Vincent and more.

Previous Spread: Image by Robert Williams
Opposite Page: Image by Peter Vincent

ANTHONY AUSGANG

Anthony Ausgang paints like a man in the throes of surrealism, Saturday morning cartoons and Van Gogh. He creates a world inhabited primarily by cats living out psycho-surreal situations that either poke fun at human nature and modern culture or obliquely criticize it. The fun and flagrantly bold nature of a hot rod fits right into Ausgang's scheme of things, and he frequently uses hot rod or automotive imagery in his paintings.

Ausgang was born in 1959 to a Welsh father and a Dutch mother. His parents moved him from his native Trinidad and Tobago to Houston, Texas, before he could read. In an attempt to immerse their son in American culture, Anthony's father would take him to track races to eat dirt and breathe exhaust, and his mother would drag him around museums to soak up the rarefied air of high art. These disparate elements conspired to inspire Ausgang's artistic bent.

Ausgang studied art at both the University of Texas in Austin and the Otis Art Institute in Los Angeles. But neither program included the steady diet of "target practice, admiring cars or surf movies" that Ausgang required for a healthy mind. So he dropped out of school and began working the gallery scene in Los Angeles until Zero One gallery took him on. According to his own account, his first paying patron was a drug dealer.

His paintings, done on the doors of a 1936 Plymouth Coupe, were featured in the "Kustom Kulture" show at Laguna Art Museum in 1993, a show that examined the anti-culture of hot-rod-inspired art. Since then, Ausgang's notoriety has grown and his work is now in museums, publications and private collections worldwide.

The Screech by Anthony Ausgang

CAR CULTURE | 15

AUSGANG

The Butt Picker

High Heel Hotrod
Following spread *Hamburger Highway*

Riding Shotgun

Ninth Life

The Attack

Los Parasitos Locos

JACK BUTLER

A native of upstate New York, Jack Butler came to Pasadena, California, at the age of 13. At that time, hot rod culture was in full swing, and when Butler got to high school, he owned a hopped-up '49 Chevrolet. Fast-forward past an intensive 35-year career and Butler finds himself interested in cars once again. In an interview with Greg Escalante, Butler described it as "an interest that was more like a passion that sat around for a while, until now."

Once Butler's passion for hot rods was rekindled, he approached it like anything else in his life and dug in deep. He found his interest lying primarily with the people building and driving traditionally styled pre- and post-war hot rods. At this time he was in the midst of a hiatus from the art world, and this new flame for hot rodding spurred him into taking pictures again—this time with a pinhole camera.

The primitive technology of the pinhole camera suits the subject and the artist's aims nicely. "The people that live in that culture initially interested me," Butler told Escalante. "I was interested in recording them and the cars that they were building. They were doing it for the love of the cars … their history fascinated me, and the culture had a lot of exaggeration. So it was that aspect that I strove to monumentalize. And the pinhole camera's aesthetics allowed me to do that." The primary image from the pinhole camera is recorded on Polaroid Type 72 film, which he then scans to create digital, archival prints.

Butler has been involved in making art with and from photography since the early 1970s. He received his Master of Fine Arts from UCLA under Robert Heinecken and has continually shown and taught ever since. Even though photography has been the banner under which his art has flown, his work covers a much broader range than the word "photo" would suggest. Much of Butler's work is of a conceptual nature, mining and exploring the margins, or using found imagery to trigger questions or emotion.

Mark Morton '54 Merc

Sammy's Roadster

Keith Weesner Ford

Aaron Kahan's '27 T

Tim Sorci '60 Cadillac

Robert Williams '32 Ford

Louis Ramirez '54 Chevy

C • CRUZ

Charlie (or simply C.) Cruz is the alter ego of Darrell Mayabb. He created the fictional Cruz character to separate his illustration work from his cartoon work.

As Mayabb tells it, "I had been selling some of my original hot rod art through a gallery. The gallery owner called to inform me that a patron who had purchased a couple of my illustrations was upset … he had seen some cartoon work I had done in recent issues of *Rod & Custom* or *Hot Rod* magazine, and his feeling was that an 'automotive fine artist' should not do cartoons. The owner wanted to know what to tell him. I said I would get back to him with an answer. Cartooning has always been a big part of my art. So I thought about it, took out a legal pad, and started writing down names."

"The one that stuck was C. Cruz; to any old rock and roller it had a familiar ring. I called the gallery owner back and told him to tell the patron that Darrell Mayabb would never do another cartoon. When life throws you a curve, try to think of a solution that pleases you and doesn't upset anyone else. It makes life fun." Cruz has been featured in *CARtoons*, *Rod & Custom*, and *Hot Rod* magazines.

34 | JUXTAPOZ

CAR CULTURE | 37

CAR CULTURE | 39

JIMMY C

Coming out of the American Southwest and a childhood full of art, James Cleveland, a.k.a. Jimmy C, is now a resident of San Clemente, California. Signage, design, products, sculptures, giant dinosaur robots, paintings, illustrations and pinstriping all emerge from Jimmy C's small storefront headquarters. He is a creator of fine art, commercial and custom work, with a to-do list that would make many artists blanch and go running home to their mothers.

As a kid in Arizona, Jimmy was nuts for off-road racing, but he also absorbed as many courses in art as he could. Through his younger brother, he met a sign painter named Michael B. in Parker, Arizona. Michael gave Jimmy a job, and his love affair with 1 Shot lettering enamel began. At this point, Jimmy was just starting out, and lettering was his main gig. Even though he was aware of the art and cars of "Big Daddy" Roth, pinstriping and "Finks" weren't on the menu yet.

In 1984, Jimmy and a friend attended one of the legendary Rat Fink reunions. Jimmy saw Roth painting trashcans and witnessed the striping of Von Dutch for the first time. Inspired by what he saw, Jimmy went home and burrowed into his art. In 1993, Jimmy was asked by Greg Escalante to provide artwork for the catalog of the "Kustom Kulture" show at Laguna Art Museum. Jimmy's striping on the show's catalog cover and his take on Rat Fink and Dutch's flying eyeball placed Jimmy and his art in the public eye for good.

Since his "debut" on the covers of the "Kustom Kulture" catalog, Jimmy has stayed incredibly busy and in demand. He's done bicycle designs for Electra bicycles and worked with toy car legend Hot Wheels. His work re-creating the cars of Ed Roth and offering them in kit form is an amazing feat of artistry and dedication to the memory of the Big Daddy.

CAR CULTURE | 41

THE BEAST

CHURCH

Coby Gewertz is "Church." On one level, Church is a brand for the "auto aficionado," on another, it is Gewertz's heartfelt expression of love for drag racing and design. Church celebrates a place that exists outside of hype and lights, or big-money braggadocio. It is a place that is spiritually within the people who race and build all the time simply because they have to.

Gewertz grew up in a blanket of nitro fumes and tire smoke along with his brother Marc. Their father, Bob, was a starter at Fremont Dragstrip in Fremont, California, who later became a top fuel driver. To keep his young sons occupied, he would draw pictures of dragsters and funny cars for them to color in. As the boys grew up, they attended races around the country and shot photos. Coby even had a business card that read "Hot Shotz Photography: You Crash 'Em, We Flash 'Em." In the end, it was his brother Marc who turned out to be the talent with the camera: Marc is now the senior photographer for the NHRA. Coby took the art and design route.

At Cal State Fullerton, Gewertz studied design and in his spare time designed paint schemes for drag cars. According to Gewertz, the impetus for Church came about "four or five years ago at the big show in Paso Robles. There were so many shitty shirts there, I came home empty-handed. It was a pretty sad day. I thought I should just design some myself, and Church was born."

Along with art prints, photography, design and T-shirts, Gewertz puts out a limited-edition magazine, also called *Church*. He says, "Here I am, 15 or 20 shirts later, and five issues deep on my magazines. Still a one-man show, all self-funded. It's one man's attempt to steer clear of the scene and keep the focus on the machines themselves." Gewertz's "little books" are beautifully rendered examples of pure automotive photographic joy that exemplify his clean sense of design.

From *Church, Premier Issue*

From *Church, Premier Issue*

50 | **JUXTAPOZ**

From *Church, The Second Coming*

From *Church, Four Play*

CAR CULTURE | 51

From *Church, Numero Tres*

From *Church, Premier Issue*

From *Church, Four Play*

From *Church, Numero Tres*

CAR CULTURE | 53

From *Church, Four Play*

From *Church, Numero Tres*

54 | JUXTAPOZ

From *Church, Premier Issue*

From *Church, Four Play*

CAR CULTURE | 55

COOP

The images are on one hand familiar and on the other completely original and new. Coop, a.k.a. Chris Cooper, creates iconic images by consuming and then re-creating the last 50 years of popular culture. Coop has so completely injected himself into his art that it is safe to say he now owns the devil, co-owns big-breasted she-devils (along with Russ Meyer), and can probably lay claim to a pair of crossed wrenches. Even the most sacred of hot rod icons, the venerable mooneyes, were once part of his signature.

Born in 1968 and raised in Oklahoma, Coop left his home state for Los Angeles shortly after the ink was dry on his high school diploma. With a head full of hot rods and Russ Meyer movies, the young Coop worked overtime to make his name. He began showing his art in the Los Angeles area, and his first solo show came in 1993 at the famous La Luz de Jesus Gallery.

Determined to make a living doing what he loves, Coop built a merchandising empire based on his artwork. Rock and roll posters, T-shirts, stickers, shot glasses, skateboards, lighters, stationery, toys and fine-art prints are just a fraction of the goods sold under the Coop banner.

A true hot rodder, Coop culls much of his imagery from the world of racing, hot rodding and car culture. Another side of Coop's artwork comes from B-movie monsters, sexploitation flicks and the world of fetish. Robert Williams, R. Crumb and Eric Stanton stand among Coop's favorite artists, and he lists the pinup painter Gil Elvgren, fetish photographer Irving Klaw and the inimitable Ed "Big Daddy" Roth as influences.

Galleries worldwide have shown his work, and Coop has published two books, *The Devil's Advocate* and a 1,008-page sketchbook called *The Big Fat One*. Coop is currently working on a companion to *The Devil's Advocate* to catalog his work since 2001, and also a book of his photography.

© Coop All Rights Reserved

CAR CULTURE | 59

© Coop All Rights Reserved

CAR CULTURE | 61

62 | **JUXTAPOZ**

© Coop All Rights Reserved

CAR CULTURE | 63

© Coop All Rights Reserved

CAR CULTURE | 65

DIRTY DONNY

Donny Gilles, a.k.a. "Dirty Donny," of Ottawa, Canada, is a psychedelic practitioner of the monster art style created by Ed Roth and Bill Campbell. Donny's drawings and paintings imagine a playful world where monsters and aliens play guitar, drive cool cars and hang out at moonlit surf parties. Where others point a mean finger or go for the sheerly crass, Donny's monsters and miscreants seem to be having the kind of good time that you really want in on.

When Donny was a teenager, he naturally gravitated toward the world of hot rods, muscle cars and old B-movie monster flicks. Donny also inhaled his share of glue while assembling "Hawk," "Weirdo," and "Revell" model kits. As an artist, he returns to mine these lodes for inspiration and material. After Donny decided to make his art a full-time job, he spent some time in the underground art, music and skateboard scene of Montreal. To give his art a broader audience, he packed his bags and headed for San Francisco.

Since moving to San Francisco, he has sharpened his skills. His confident line work and attention to detail has allowed him to make a living doing what he loves most. Donny's repertoire includes a design for Steve Caballero's new skateboard, album-cover art for the Hellacopters and the Demonics, custom pinball machines, ceramic tiki mugs and even a wooden drugstore Indian he striped for Metallica's James Hetfield. Donny is developing his creations into toys and gadgets, working on his 1969, 440-powered Plymouth Satellite, and is currently involved with a notorious mini-bike gang.

CAR CULTURE | 67

68 | JUXTAPOZ

CAR CULTURE | 69

CAR CULTURE | 71

CAR CULTURE | 73

MARK D'ESTOUT

Marc D'Estout grew up in the San Francisco Bay Area and went to high school in Fremont, just within earshot of the famous (now-defunct) Fremont Drag Strip. He received his Master of Fine Arts from San Jose State University.

D'Estout expresses his natural inclination for all things automotive through sculptural works, graphic design and photography. He calls his work in the sculptural realm "domestic objects." Tables, chairs, shelves and lighting all use elements of the automotive form or build techniques. In much of his work a "minimalist, refined distillation of form conveys the conceptual underpinnings of the work, while service and utility remain essential."

It is true that the love of automobiles is one of D'Estout's passions, and it is by no means a humorless one. His car club, known as the Odd Rods, requires of its members ownership of a pre-1965 vehicle from a manufacturer no longer in existence. They claim to be the "world's most dysfunctional" car club. D'Estout's title, as ringleader of the club, is "The Odd Father." His humor finds an outlet in his art as well, notably in the Ghoul Shifters line of cast shifter knobs he has produced.

When he's finished helping fellow "Odd Rod" club members push their jalopies over state lines, D'Estout finds the time to be the art director for *Hop Up Magazine* and aftermarket parts companies Crime Scene Choppers and Santa Cruz Speed and Custom. His work has been shown in galleries and museums across the country, and he has worked as the assistant director of the Triton Museum of Art, art director and curator of the Monterey Peninsula Museum of Art, and director for art and design at the University of California, Santa Cruz extension. The Thompson Gallery at San Jose State University recently produced a comprehensive, full-color monograph to explore and interpret the past two-and-a-half decades of his art and design.

CHRIS FROGGETT

Working in gouache and airbrush, Chris Froggett stretches time and proportion. In his paintings, tires reach out of the frame directly at the viewer, while injector stacks veer off in another direction.

Froggett lives in the north of England in a small town called Kirkburton, just south of Leeds. "It was my old man who got me into art," Froggett says. "He used to draw great cartoons for me and my little sister when we were kids, and at some point in my early teens it had been decided by someone that I would be employed in my uncle's commercial studio on leaving high school."

In the industrial north of the 1960s, there was not much in the way of American-style car culture. Froggett occasionally found a copy of Hot Rod, and he quips, "the nearest thing to a rod was if my old man came home in the [factory] VIP '62 Impala." It would not be until the 1970s that a hot-rod scene of any sort would spring up, and even then it was "a few Fad tees, but mostly beach buggies and vans."

Working at his uncle's studio taught Froggett a great deal, but it was not where his heart was. Eventually unemployment got Froggett to develop his art into a vehicle to make a living. He began selling art at rod runs and car shows in the early 1990s. His style was plainer at first, but eventually the influence of Dave Deal and Lance Sorchicks took hold and a bolder style emerged.

Since he began selling series of prints in the late '90s, Froggett has worked for a wide range of clients, from Jimmy Shine and So-Cal Speed Shop to Stromberg Carburetors and SpeedTV.

84 | JUXTAPOZ

CAR CULTURE | 85

CAR CULTURE | 87

CAR CULTURE | 89

PAT GANAHL

Even though Pat Ganahl originally went to school to become an automotive-chassis designer, he later became an English literature major, and has established a long lasting and distinguished career in hot rod automotive journalism and photography. His name has appeared on countless stories since he first got a job as editor of *Street Rodder* back in 1974.

Ganahl's personal, insightful writing style, combined with his keen photographic sensibilities and sharp editing skills, led to him holding editorial posts at *Hot Rod*, *Rod & Custom* and *The Rodder's Journal*. He also served for three years as an editor at *Sunset Magazine*.

In addition to the magazine work, he has published how-to books for hot rods and customs and has written definitive works on Ed "Big Daddy" Roth and legendary striper Von Dutch. Ganahl says, "I've lost count, but I think I've done 12 books now." In addition to his journalistic work, he has built many hot rods and race cars, and he continues to do so. Although he is loath to classify hot rods as art, he acknowledges their place as a form of self-expression and an American tradition. He has published writing on the subject of hot rods as art—or not art—in museum catalogs and in many books. He has curated and co-curated shows in museums featuring automotive art as well as hot rods.

Ganahl's passion for photography began when his father, an amateur photographer, gave him a camera when he was 10 years old. Ganahl began to see photography as an art form after being exposed to the work of the great American masters when he was a young man. Dorothea Lange and Edward Weston hold a special attraction for Ganahl, and his photos today resonate with their influence.

CAR CULTURE | 91

CAR CULTURE | 93

BRUCE GOSSETT

Bruce Gossett was born in St. Louis, Missouri. His stepfather was an auto dealer, and throughout his childhood there was always "a killer ride in the garage." As a youngster, Gossett took up drawing and painting to escape from the car world but ironically wound up drawing and painting cars in Sacramento, California.

The ink and paint have been seriously flying since 1999, when Gossett opened Black Cat Press with Ira Cowart. At Black Cat, Gossett and Cowart tackle design jobs, concert posters and T-shirt work. Silk-screening is just one facet of Gossett's art; he also uses painting, drawing, striping and lettering as creative outlets. All manner of media and surface are employed, and even the demon airbrush or a Binks HVLP spray gun can be found cradled in his fingers.

Arising from the wreckage of modern day "lowbrow," Gossett employs a rougher-hewn style and earthier palette than many of his contemporaries. Mexican folk art, fireworks packaging, comic art, automobilia, Americana, pulp themes and sex all figure into the Gosset frame. He pushes himself to continually experiment and create something original.

Gosset is no stranger to the pain of the wrench either. A '54 Plymouth Savoy, '54 Plymouth wagon, '40 Chevy pickup, '37 Plymouth "Humpback" sedan, '65 Fury, his partner Yvette's '66 Pontiac Bonneville and '65 'Cuda have all received bits of his flesh and drops of his blood.

DARRELL MAYABB

Long before illustrator and painter Darrell Mayabb said, "Art has taken me many places inside and outside of myself," he was a teenager growing up in the 1950s. A native son of Dayton, Ohio, the young Mayabb was obsessed with hot rods and spent hours hunched over hot rod magazines. Mayabb would lie on his bedroom floor, pencil in hand, attempting to copy Stroker McGurk, a comic strip character by Tom Medley that ran in *Hot Rod*. In school, Mayabb says, "Art was considered OK as a hobby, but you needed a real job to get along." Even though he did T-shirt art and pinstriped cars, he considered his "real job" to be the one he held at the grocery store.

Mayabb's high school art teacher handed him an index card with the art of Salvador Dali on it, and his life took a new course. On that day, he realized Dali had influenced Von Dutch; consequently, Mayabb's focus on art widened and intensified. After attending art school, he left for Southern California, checked in on Roth Studios and decided it was not for him. Instead, Mayabb took a job as an illustrator for the Apollo program with North American Aviation. In 1967, he married his sweetheart, Sharon—with whom he is "still madly in love"—and together they had two children, Jonas and Chelsey.

Mayabb's work shifts between classic stylistic studies and playfully proportioned paintings used in PPG automotive paint promotional posters. He has worked for the magazines he once worshipped as a teen, and he has gotten to meet, befriend and work alongside heroes like Tom Medley. In the summer of 1999 he received the Stroker McGurk award from *Rod & Custom*, and in 2006 he received the honor of being inducted into the *Rod & Custom* hall of fame. Mayabb resides outside of Denver on four acres looking up at the Rocky Mountains.

CAR CULTURE | 107

110 | JUXTAPOZ

CAR CULTURE | 111

M. C. McMILLEN K7B13

M.C. MCMILLEN

In 1946, when Michael C. McMillen was born, the town of Santa Monica still had dirt alleyways, plenty of sunshine, and a beach-side vibe. World War II brought jobs and prosperity to the town. Prosperity meant possessions, and possessions meant good trash picking for a boy like McMillen. He says, "It was the early 1950s, and I would collect old tube radios, WWII surplus and other objects of interest for later dissection under my grandfather's workbench." This curiosity later yielded to a "strong desire to make art, to explore ideas and raise questions through the creation of objects and images. At that time I thought I wanted to be an inventor and would spend hours recombining parts that now would seem more like art objects than practical widgets."

Growing up in the Los Angeles basin in the early 1950s automatically put McMillen in the heart of the post-war American hot rod movement. His brother Joel ran an "AA" gasser out at Lyon's, and Michael would frequently be out there watching him. The art McMillen creates is well served by both his experience with early hot rod culture and his alley-prowling, junk-collecting ways.

Like the installations he creates, McMillen's backyard and studio is an accumulation of things that he uses. It's his own junkyard palette, subject to weather and the whim of its owner. His yard may be more in flux than a typical installation, but some of his installations are hands-on and subject to change as well. An installation like the garage (precisely titled "Central Meridian") is an immersive experience for the viewer, and it is hoped that it will transport the viewer out of the present time and place to an imagined realm where the mind can construct its own narrative.

Not one to be pigeonholed, McMillen refers to himself as a visual artist. He freely moves around the broad spectrum implied by such a title and is a sculptor, painter, photographer, builder, provoker of thought and caretaker of phenomena. The art he creates resides in public spaces, galleries, collections and museums.

Photos © 2009 M.C. McMillen

Photos © 2009 M.C. McMillen

Photos © 2009 M.C. McMillen

PETE MILLAR

Born December 14, 1929, Peter Millar was a cartoonist with a recognized and lasting influence on both automotive art and cartooning. His first work was featured in *Rod & Custom* in 1953. In 1959, Millar teamed up with Carl Kohler and created what was to become the longest lasting and most influential title in automotive cartooning, *CARtoons*. By 1963, *CARtoons* was a success, but Millar was no longer part of the operation.

Millar went on to start up his own comic book called *Drag Cartoons*, which published successfully from 1963 to 1968 and was resurrected briefly in the late 1990s and saw its final issue published in 2000. Millar also published a full-color annual titled *Drag Comics* from 1971 to 1973. Because Millar published the titles himself, the art could skirt the goody-two-shoes image the NHRA was so desperate to foster. Along with his own artwork, Millar allowed his comic books to be springboards for other artists as well, notably Tony Bell and Gilbert Shelton's Wonder Wart-Hog and four issues of *Big Daddy Roth Magazine*.

Millar's intimate knowledge of his subject matter gave him an advantage other cartoonists could only wish for. Not only was Millar an engineer, fully vested with working knowledge of dragsters and hot rods, he was a racer and enthusiast himself. His comics are so endearing to racers and rodders because Millar "gets it," and the details he puts into the drawings make every knuckle buster feel right at home. Perhaps the quality most appreciated by gearheads of every stripe was Millar's fearlessness when it came to his subject matter and his courage to portray things as he saw them.

Ultimately, Millar was ahead of his time. His unique combination of drafting skill, insider knowledge, playful humor, curatorial eye, journalistic bent and creative urge made him what writer Dave Wallace called "one of the most-respected and most-powerful media figures in an era overflowing with journalistic talent." Millar continued to draw until the end of his life in 2003.

CAR CULTURE | 127

ED NEWTON

Ed Newton grew up in San Jose, California, back when scenes from the movie *American Graffiti* were being played out in real life. After high school's hot rod hi-jinx, Newton went to UCLA for two years on an art scholarship. He completed his formal art education at the Art Center College of Design. It was during these years that he began airbrushing designs on T-shirts, calling his product "Newt's Way Out Shirts." His predilection for hot rodding and skill with an airbrush, coupled with his original ideas, landed him a job at Ed "Big Daddy" Roth's studio.

Newton designed countless T-shirts throughout the 1960s while working at Roth's. He helped design the famous "Orbitron" show car with Ed Roth and is responsible for custom Roth creations like "The Wishbone," "California Cruiser," "Candy Wagon," "Surfite," "Captain Pepi" and "Druid Princess." Many of his designs have also become model kits or Mattel Hot Wheels and have had a direct effect on the growing minds of young boys and girls. When Roth closed his studio in 1970, Newt moved to Ohio to become the creative director for Roach Studios.

The recent rise of the pop surrealist art movement also known as Kustom Kulture has created a renewed demand for Newton's "frozen motion" style of art. He still enjoys this type of "retro" work but now prefers the additional options available with large-format oil-on-canvas creations. He has designed and animated cartoons for MTV/VH1, created specialty logos for Ford Motor Company (through J. Walter Thompson) and collaborated on a book called *How to Draw Crazy Cars and Mad Monsters like a Pro*. Newton's art has been exhibited in galleries such as the New Langton Arts (San Francisco, CA), Laguna Art Museum (Laguna Beach, CA), Works Gallery (Costa Mesa, CA), G.M. Design Center @ SEMA (Las Vegas, NV), Art of Wheels @ CCAD (Columbus, OH), and a Roth retrospective at the Petersen Museum in Los Angeles.

CAR CULTURE | 129

CAR CULTURE | 135

DAVID PERRY

David Perry began taking pictures and making movies as a youngster in Southern California when his uncle "Lucky" handed him an 8mm Brownie movie camera back in 1969. He attended Art Center College of Design in Pasadena, California, to study photography and opened his first studio in the Little Tokyo district of Los Angeles in 1986. Naturally interested in cars, he began shooting the American underground hot rod scene in 1991. Perry's photographic vision first came to fame in the hot rod world with his book *Hot Rod* (Chronicle Books, 1997).

Hot Rod revealed a close look at the world of American underground hot rodding and lakes racing. The book pays as much attention to the participants and their surroundings as it does to the cars themselves. High contrast and, oftentimes, stark black-and-white imagery brought out Perry's skill as a printer as well as a lensman.

Since *Hot Rod*, Perry has been training his lens on two of his favorite subjects: beautiful women and automobiles. The first result, *Hot Rod Pin-Ups* (Motorbooks International, 2005), was so successful that Motorbooks published a second effort in 2008 titled *Hot Rod Pin-Ups II*.

Along with *Hot Rod* and *Pin-Ups I* and *II*, Perry has published *Billy F. Gibbons: Rock + Roll Gearhead*, *Hot Rod Kings* and *Bordertown*. His photographs have appeared in galleries, museums, advertisements and catalogs. When he is not releasing a shutter or on a dry lakebed, he is at home in Vallejo, California, taking care of business and his son, August.

CAR CULTURE

THE PIZZ

The Pizz is the beatnik's beatnik, the illustrator's illustrator. He is a painter of sophisticated style manifestos and a cartoonist of cultural mayhem, beer-drinking molls and skeletal ne'er-do-wells. When he paints a surrealist take for an automotive ad campaign, he stretches, elongates and lowers the car with lines and paint, the same way a customizer would do it with lead and sawzalls. Details become entire worlds, and the whole scenario becomes a freak scene populated by nightmares and spectral sex goddesses.

As a miscreant teen, the Pizz was forever filling notebooks with hieroglyphics and cartoon masterpieces. He did his time at Roth Studios, turning out Rat Fink comics. Renegade record label Sympathy for the Record Industry has enlisted the talents of the Pizz for album-cover art, and his designs have been rendered onto skateboard decks, tattoo flash and mass-murderer trading cards. He has shown regularly at La Luz de Jesus Gallery in Los Angeles, and the gallery co-published his book, *The Atavistic Avatar: The Cartoon Brut Art of The Pizz*, with Last Gasp.

The Pizz lives with his wife in Long Beach, California, in a home decorated with African, Polynesian and tiki objects and ephemera that inspire his art. The proclaimed "Lord of Lowbrow" cruises the streets of Long Beach in a 1958 Chevrolet Bel Air and hardly ever leaves the flea market empty-handed.

CAR CULTURE | 147

CAR CULTURE | 151

SARA RAY

Sara Ray's roots are steeped in Southern California hot rod culture and surf lore. She was born in Hermosa Beach, California, to a family of artists, surfers and hot rodders. She grew up under the volcano on the Big Island of Hawaii, riding around in rusty hot rods and surfmobiles. Her grandfather was surf legend Hap Jacobs, and customs by George Barris shared space with hot rods in the family garage. The self-taught painter's childhood and family influences have been prime motivators for her artwork.

Ray is also an avid war historian with a special interest in WWII iconography. Her interest in the war plays a major role in her paintings and her life. She loves to visit war museums and interview veterans.

The consummate hot rod artist, Ray wrenches on her cars whenever she can and is a firm believer in the Viking saying, "Buy a steed when it is lanky and a sword when it is rusty." She owns a 1942 Ford jeep that saw action in WWII, a 1939 Cadillac La Salle dressed up like an army staff car in honor of George S. Patton, and a '53 Buick she calls the "Prussian Widow."

Ray's thinly layered oils portray a heady mix of nose art, pulp fiction, fascination with "Kustom Kulture" and the supernatural. She has recently begun mounting solo exhibitions of her work and has shown alongside fellow car culture mavens Coop, the Pizz, Suzanne and Robert Williams and Von Franco. Her art has been featured in magazines from *Easyriders* to *Guitar Player*. She has done work for Fender, Gretsch and Jackson guitars, and recently completed a series of custom-painted motorcycles for Sucker Punch Sally's. Ray currently resides in Long Beach, California.

Ruined And Wasted

Pride Of The Fleet

CAR CULTURE | 157

Black Tar Day

The Trouble With Zombies

Luck Low Roll

Homewrecker

CAR CULTURE | 161

CHARLIE SMITH

As a youth, Charlie Smith stayed one step ahead of the truant officer while keeping his nose buried in rod and custom books and magazines of the late '50s and early '60s. In every picture and every article, Smith zoomed in on the details, learning the rules of proportion. He got his start by lugging his brushes and paints to garages and racetracks, striping hot rods, racecars and customs before he was old enough to drive. With the money he earned, he began building a custom 1951 Ford. By the time he had his license, the '51 was a ready and able calling card that garnered Smith a job at a local custom shop.

In 1965, the army drafted Smith and shipped him off to Germany. He credits the years he spent there with broadening his design and artistic horizons. Upon returning home, he went to the Kansas City Art Institute to finish his formal artistic education. After earning his degree, Smith went into advertising and design, eventually opening his own firm. Throughout the '70s, he worked the rock and roll angle from a design, musical and managerial position.

In the 1980s, Smith returned to his hot-rod roots and formed a clothing company called Top Flite Concepts that produced award-winning sportswear. Along the way, he remained involved with rod and custom builders, designing radical customs and automotive-related products. His illustrations have appeared in *Hot Rod*, *Rod & Custom*, *Street Rodder*, *Custom Rodder* and *Nitro* magazines. Today Smith lives in Kansas City, Missouri, and runs *Motorburg*, an automotive art and culture website.

THOM TAYLOR

Several of today's most famous hot rods began their lives at the hand of designer and illustrator Thom Taylor. His custom designs have won the "America's Most Beautiful Roadster" award four times since the completion of his first widely recognized work, the Vern Luce Coupe. Since then, he has created the Frankenstude; the Chezoom; Ashley Webb's Wedge roadster; Dan Fink's Speedwagon Deuce woodie; and the Riddler-award-winning 1933 Coupe of Bob Reed. Two of Taylor's designs—the Bob Kolmos Phaeton and Dan Fink's Speedwagon—were named to a list of the "75 Most Significant 1932 Ford Hot Rods" of all time. This honor is no county-fair blue ribbon when you consider the fact that thousands and thousands of 1932 Ford hot rods have been built in the last 75 years.

Taylor was born and raised in Whittier, California. As a child he constantly drew cars, and by the time he was a teenager he was not only drawing them but building them too. The custom creations of George Barris and Ed Roth, along with the art of Pete Millar, Ed Newton, Steve Swaja and Tom Daniel, fueled Taylor's creative fires. By the time he was ready to graduate high school, Thom knew he wanted to design cars.

After he graduated from Art Center College of Design in Pasadena, California, he moved to Indiana to work for International Harvester. The weather was too cold for the So-Cal native, so he returned to the warmth, sun and hot rods of his youth.

Taylor's work has been featured in nearly every automotive magazine there is or was. He has authored several books on hot rods and customs, and has been inducted into both the Hot Rod Magazine Hall of Fame and the Grand National Roadster Hall of Fame. Home is in Laguna Niguel, California, with his wife Lisa, and their children, Chloe and James.

174 | JUXTAPOZ

CAR CULTURE | 175

CAR CULTURE | 177

178 | JUXTAPOZ

CAR CULTURE | 179

PETER VINCENT

Peter Vincent spent his early childhood in the hot rod-laden orange groves of Palo Alto, California, before moving to Pocatello, Idaho. Pocatello represented a new and foreign environment, and as the family rolled into town, the young Vincent thought, "What are we doing here?" The good news was that Pocatello had eight junkyards, and driver's licenses were available to 15-year-olds. So, at the age of 15, Vincent grabbed a license, a '47 Ford Club Coupe, and a new addiction that persists to present day.

In his early 20s, Vincent "went nuts for photography." He taught himself the craft by studying the American masters of Group f/64, such as Edward Weston, Alfred Stieglitz and Ansel Adams. For the past 40 years he has explored the medium in its myriad forms, from minimalism and formalist abstraction to landscape and popular culture.

For the past decade or so, Vincent's interest in hot rods, specifically traditional and landspeed cars, has melded successfully with his photography. In a sense, he has returned to his roots in both areas. He regularly attends the meets out on the Bonneville Salt Flats and the dry lakes of Southern California to photograph the cars and the people he loves and respects so much. To capture the true feel of time travel and get to the nitty gritty of the culture, he has made cross-country pilgrimages in Flathead-powered coupes with the Rolling Bones and spent much of his time working on his own cars and bikes.

Vincent has published several titles devoted to his photography, including *Hot Rod: An American Original*, *Hot Rod: The Photography of Peter Vincent* and *Hot Rod Garages*, all on Motor Books International. His photos have been featured regularly in *Hop Up Magazine*, *The Rodder's Journal* and *Rod & Custom*. His work has been featured in collections, museums and galleries across the United States. Vincent currently resides with his wife Kim in Moscow, Idaho.

182 | JUXTAPOZ

CAR CULTURE | 183

KEITH WEESNER

Keith Weesner's feel for the right automotive proportions in his drawings and paintings has endeared himself, and his art, to the most hardcore of hot rodders. His ink drawings turned T-shirt designs are among the most sought after in hot rod circles. His paintings have a washed out and worn look that conjure an old movie set feel. They look as though they would be equally at home as pulp paperback covers, model kit box art, or framed and hung in the home or garage.

In a Weesner painting, the men are brutish, and there is an overt Frankensteinian vibe to some of them. Weesner's women, often scantily clad pinups, offer a sense of come-hither comfort—to just the right brute. The softness of Weesner's technique takes much of what is hard-boiled out of the stories told in the paintings and replaces it with a dreamy, longing feeling.

Weesner studied automotive design at the Art Center College of Design in Pasadena, California. He has been pushing ink, graphite and paint around on paper since he was a toddler. His inspirations include golden-age illustrators like N.C. Wyeth and 20th century painters like Hopper and Sargent. His brushed-ink style comes from the solid foundations laid by Robert Williams, Ed Newton and Rex Burnett.

Weesner worked in animation for 13 years, mostly doing background designs at Warner Brothers on Bruce Timm's *Batman*, *Superman*, *Batman Beyond* and *Justice League* series. He was also instrumental in the *Batman: Mask of the Phantasm* and *Return of the Joker* features, as well as the Powerpuff Girls feature for Cartoon Network and Gary Baseman's *Teacher's Pet* at Disney. Weesner has done at least two solo shows a year at the Copro Nason and Outre galleries over the past four years.

CAR CULTURE | 191

ROBERT WILLIAMS

Robert Williams is acknowledged worldwide as the founder of the "lowbrow" art movement. No other artist has so successfully melded such disparate genres as cartoons, sideshow art, illustration, realism and surrealism. His paintings are richly detailed narratives and, sometimes, tributes to hot rod and custom culture and crumbling Americana. His style is instantly recognizable and has influenced countless artists. The life he has led in the world of art, outlaws, hotrodders and publishing is the stuff of legend.

Williams was born in 1943 in Montgomery, Alabama. His father, Robert W. Williams, and his uncle Ralph were both entrepreneurs. The brothers opened a drive-in restaurant called the Parkmore, which quickly became a haven for post-war hotrodders. These hot rods and hotrodders had a tremendous influence on the young Robert. At the age of 11, Robert's father bought him a '34 Ford five-window coupe. The car became an obsession, and before he had a driver's license, Robert loved to tie the steering wheel hard left, or right, and let the car run in a circle while he walked the running boards.

After high school, Williams attended Los Angeles City College, and it was at LACC that he met and fell in love with his wife Suzanne. After LACC, he studied painting at the Chouinard Art Institute. Fresh out of school, Williams quickly realized that the fine-art world of the mid-1960s had no room for a purveyor of street life, hot rods, monsters and representative art. His break came when he got a job designing T-shirts for legendary artist Ed "Big Daddy" Roth. At Roth's studio, Williams was encouraged to cut loose, and it was there that he developed one of his best-loved and most recognizable characters, the infamous Coochy Cooty.

Today, Williams lives in Los Angeles with his wife. He still owns his influential '32 Ford coupe "Aces and Eights," except that now it is controversially painted in a racer's livery of purple and gold and has had its name changed to "Prickly Heat."

CAR CULTURE | 201

Blue Collar Bravado

Cowboys and Amoebas

ROBT. WMS.

A SALUTE TO THOSE CRAFTSMEN WHO WERE...

CAR CULTURE | 207

208 | JUXTAPOZ

CAR CULTURE | 209

ARTIST INDEX

ANTHONY AUSGANG
www.ausgangart.com

JACK BUTLER
www.jackbutlersart.com

C • CRUZ
www.automotivegraffiti.com

JIMMY C
www.kustomart.net

CHURCH
www.carsnotculture.com

COOP
www.coopstuff.com

DIRTY DONNY
www.dirtydonny.com

MARK D'ESTOUT
www.domesticobjects.com

CHRIS FROGGETT
www.atomichighboy.com

PAT GANAHL
www.RPGAN@Charter.net

BRUCE GOSSETT
www.brucegossett.com

DARRELL MAYABB
www.automotivegraffiti.com

M.C. MCMILLEN
www.lalouver.com

PETE MILLAR
www.laffyerasphalt.com

ED NEWTON
newtinator@gmail.com

DAVID PERRY
www.davidperrystudio.com

THE PIZZ
www.thepizz.com

SARA RAY
www.sararayart.com

CHARLIE SMITH
www.motorburg.com

THOM TAYLOR
www.thomtaylordesigns.com

PETER VINCENT
pvincent49@hotmail.com

KEITH WEESNER
www.keithweesner.com

ROBERT WILLIAMS
www.robtwilliamsstudio.com

CAR CULTURE | 211

Image by David Perry